#55

PLAYA VISTA BRANCH LIBRARY
6400 PLAYA VISTA DRIVE
LOS ANGELES, CA 90094

P9-CSA-124

#55 PLAYA VISTA

SEP 16 2014

Leo Timmers

# Happy with Me

xz
T

2167 87573

smallfellow
press

All day long I'm me, but
every night I don't have to be.
I just open my favorite book,
Look at the pictures,
And before I know it,
I'm dreaming...

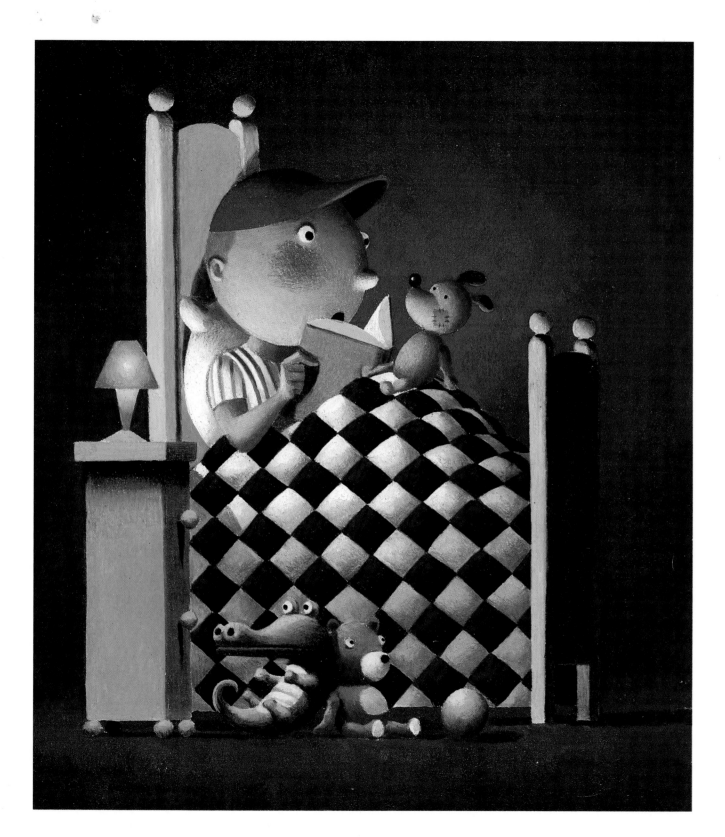

# I'm an elephant!

And not just any elephant,
but the biggest, strongest,
bravest elephant there ever was.

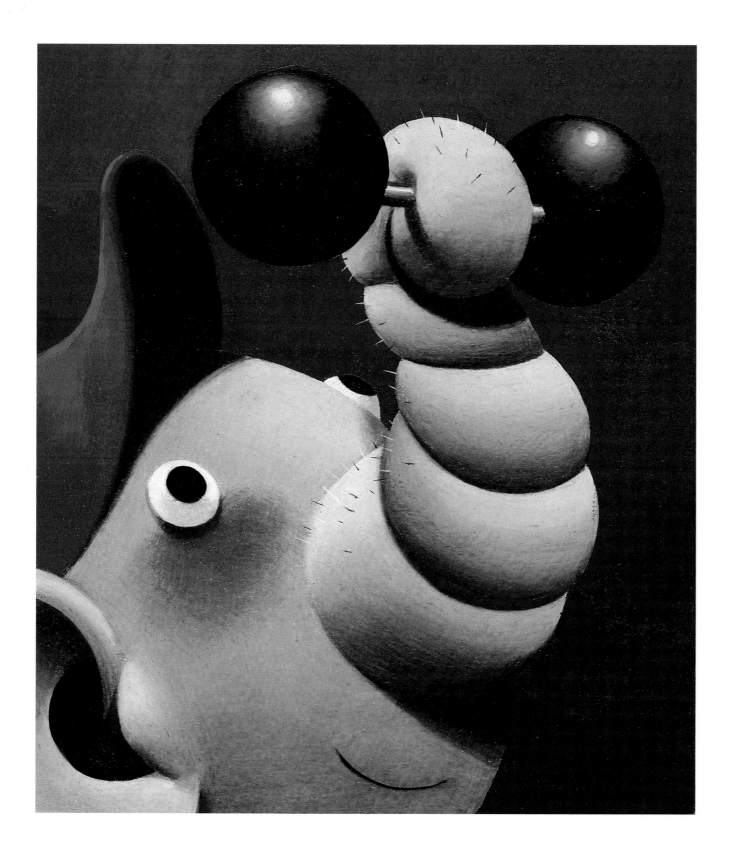

But wait!
An elephant's awfully wide.
I'll have to remember
what I'm sitting beside
and I don't want to do that!
Maybe I'd better be…

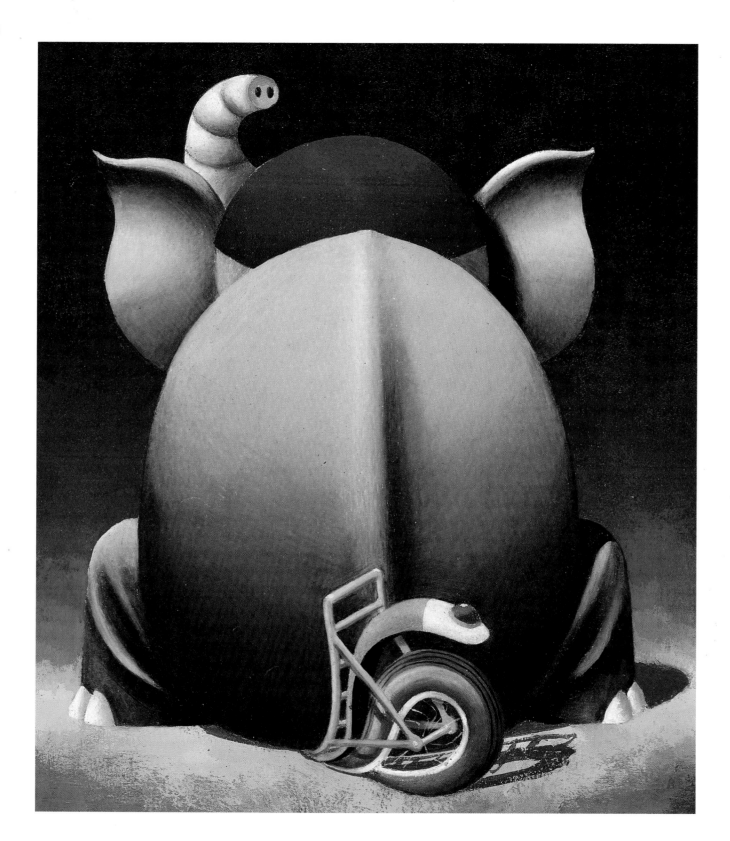

# A Penguin!

I'd get to play in the snow—
even in my most formal clothes—
and with fins for feet,
I could splash in the cool,
clear water all year round.

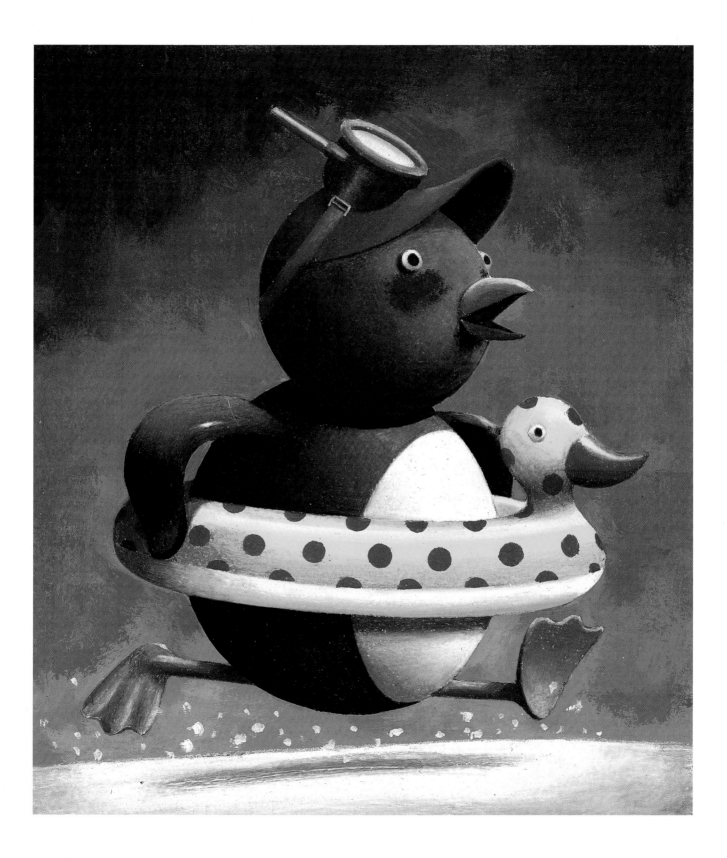

But hold on!
If I were a penguin,
my pool would freeze
and so would my feet and
that would be sad to see.
Maybe I'd better be...

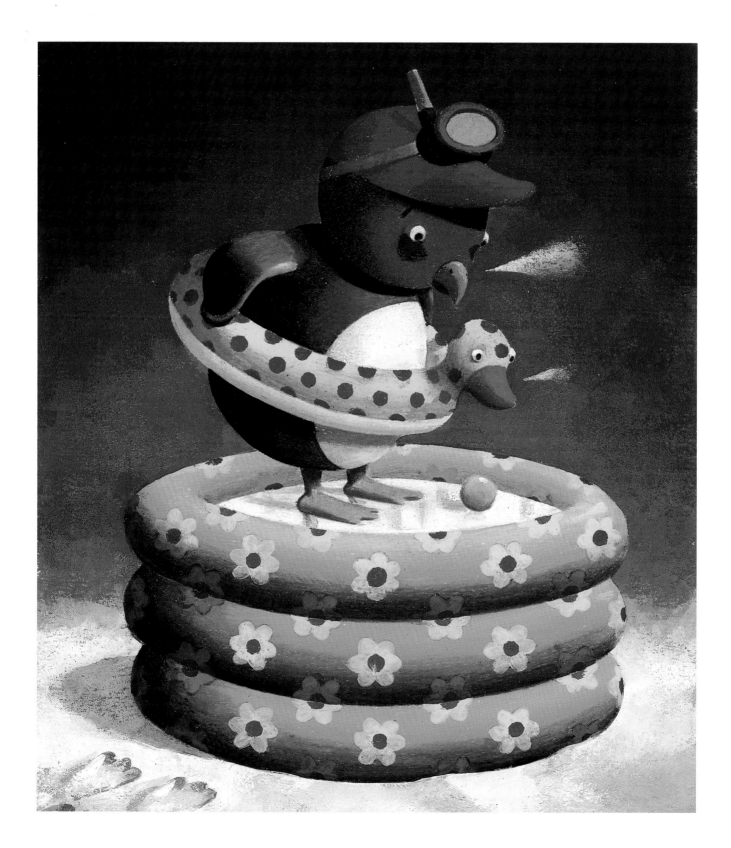

# An octopus!

With eight long arms that wind
around each other,
I'd have as much fun as
four kids together!
And think how much faster
I could get everything done!

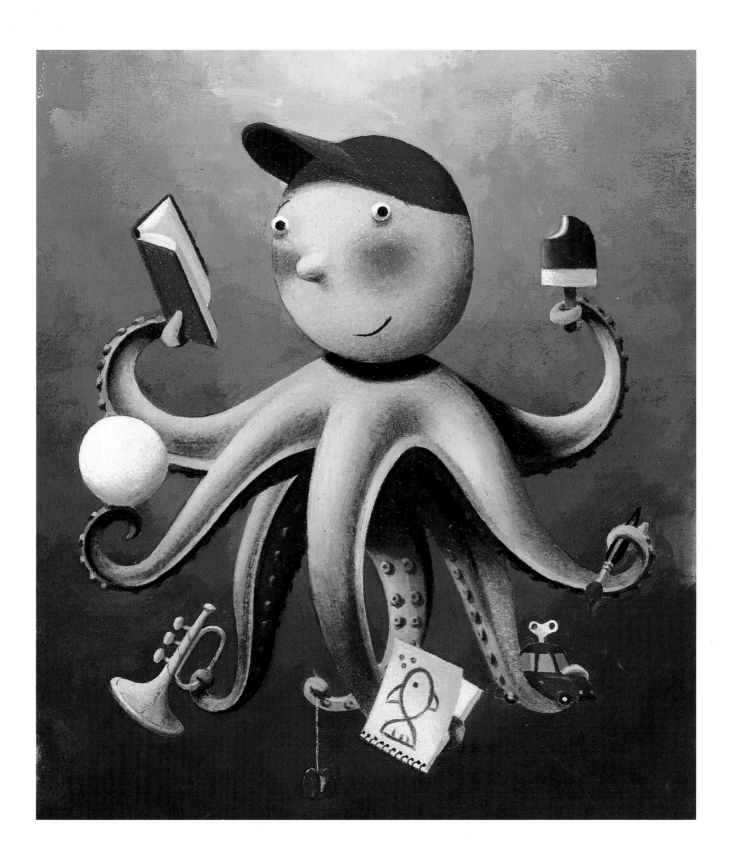

But on second thought,
being an octopus is tricky.
One wrong turn and
I've gotten all twisty,
and untying knots can be
such a problem.
Maybe I'd better be...

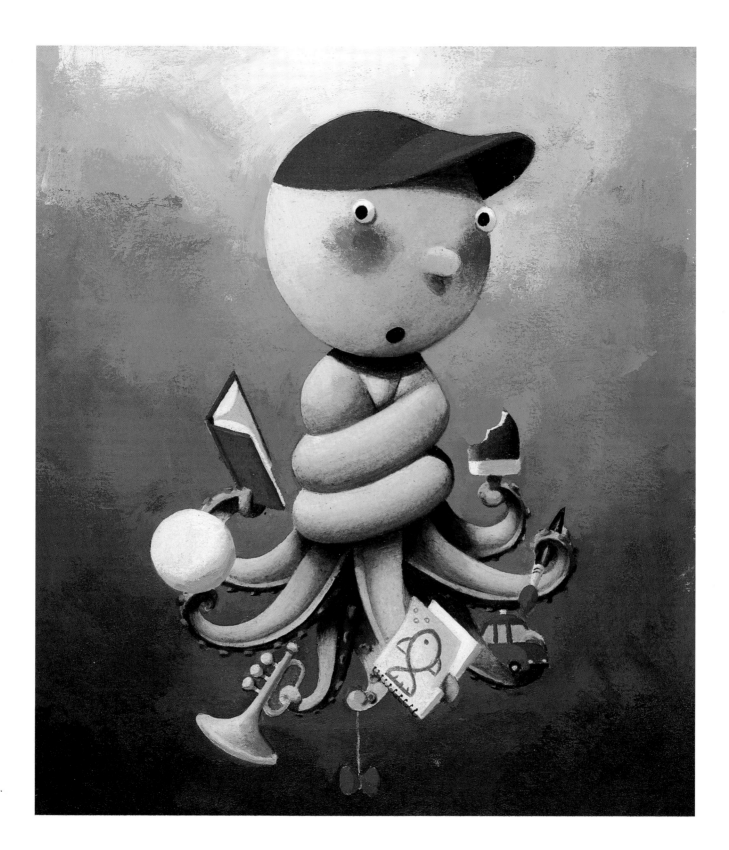

# A snail!

I won't have to try to do too much
or even do it too fast.
A snail likes to take it easy
and relax.

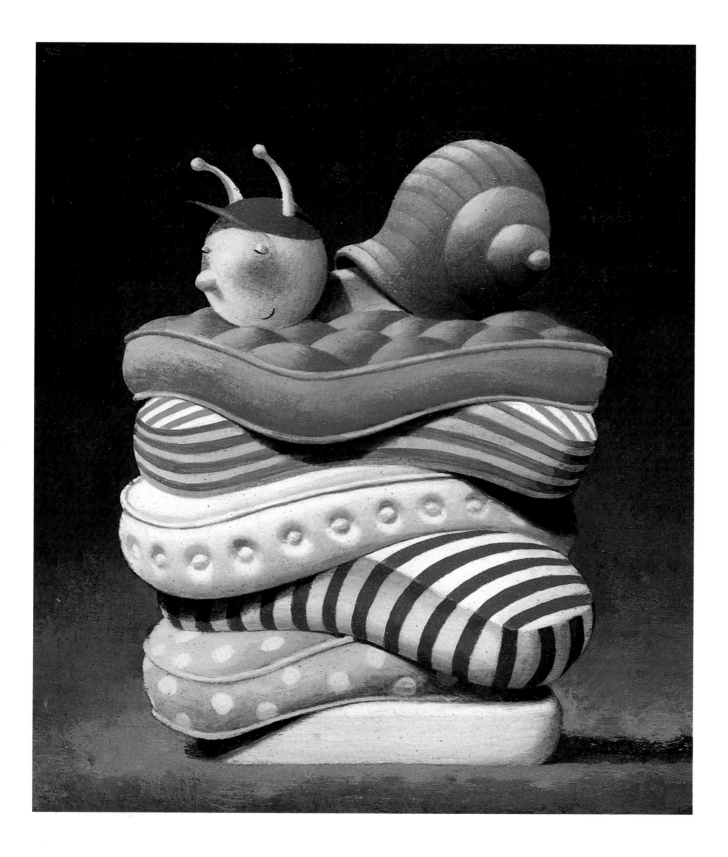

But forget it!
Moving along at a snail's pace gets
me to the party much too late.
I'll miss out on the cake and all of
the games and that's not fair!
Maybe I'd better be...

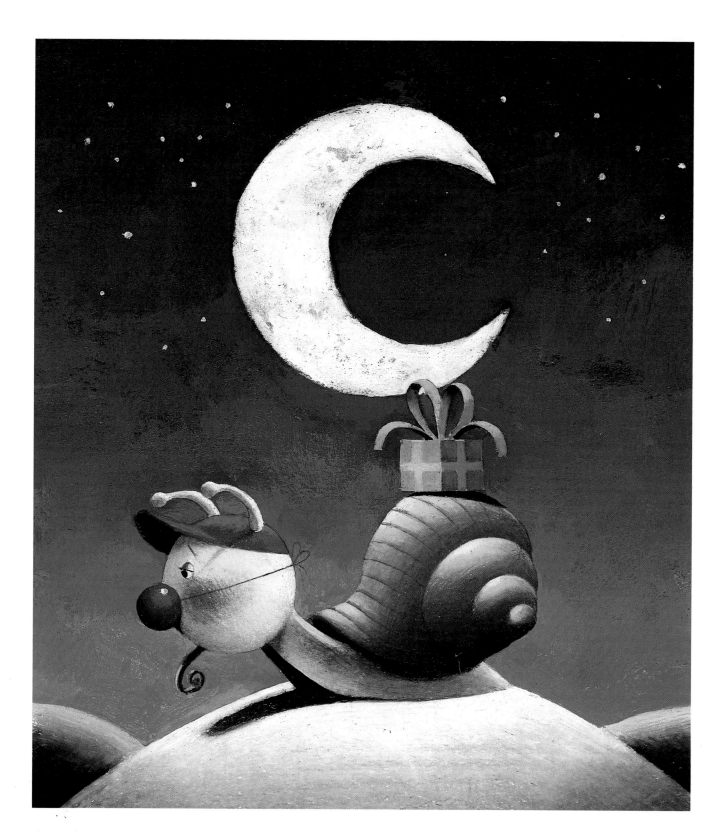

# A dog!

And not just your common
everyday dog,
but the greatest super sniffer
of all time!
Uncovering all the candy and
bubble gum anyone's left behind.

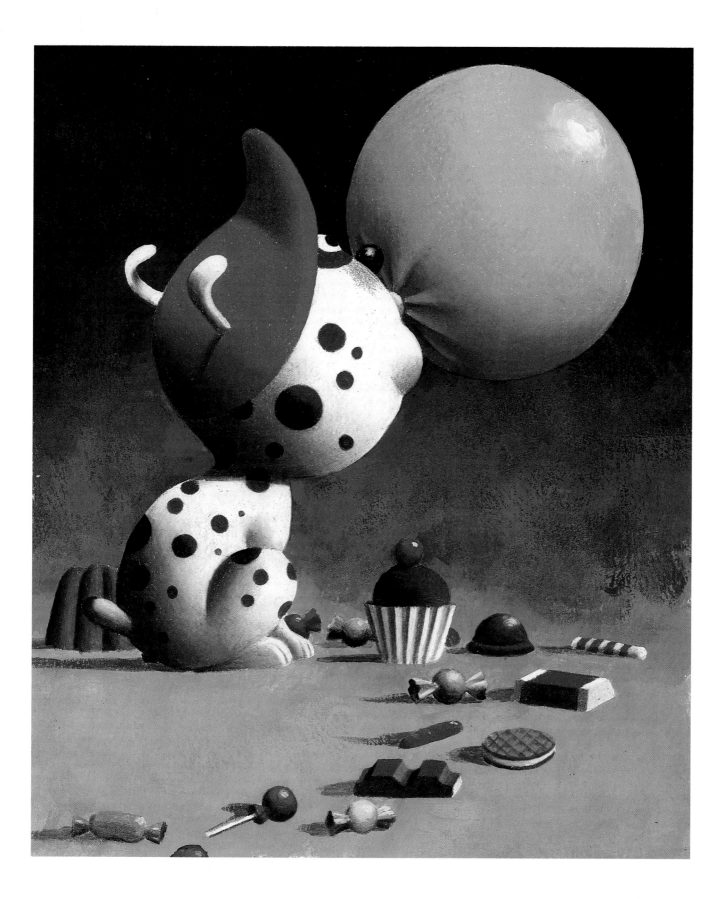

But EEE-YOO!
My sniffer will also get wind of
stinky socks, sardine tins and
moldy old cheese.
And I wouldn't want any of
those up my nose!
Maybe I'd better be…

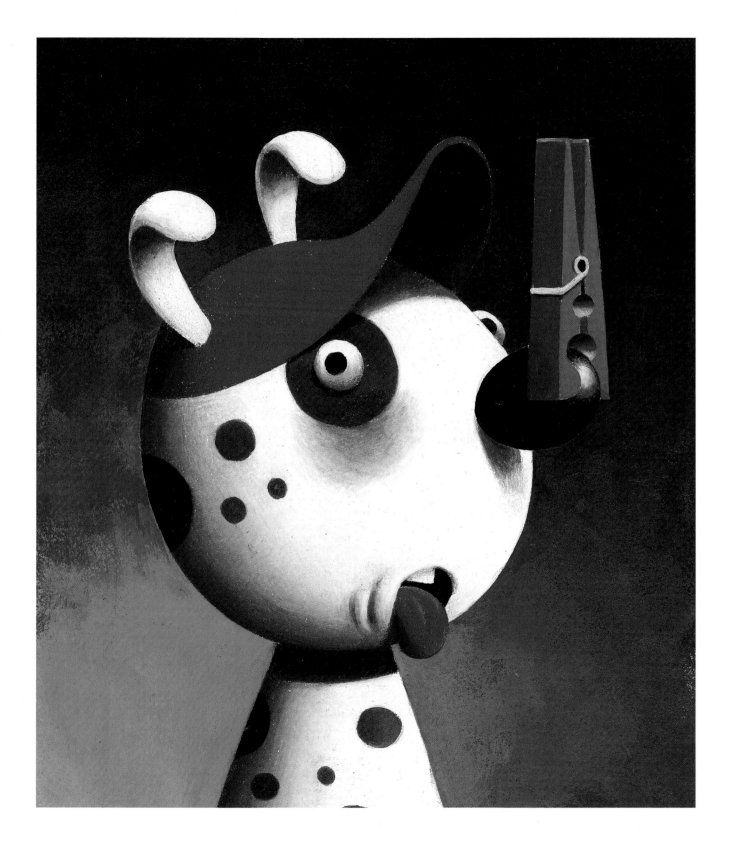

# A Bird!

Just think of it,
everything I own is on my back.
I'd sleep in the trees,
sail on the tail of the wind
and fly all over the world!

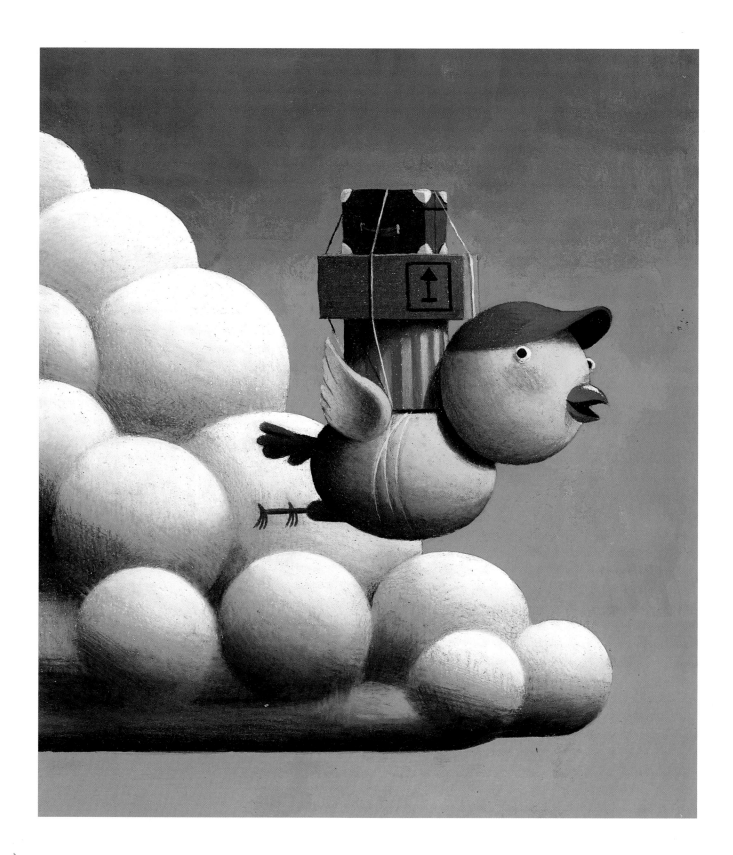

But hang on!
What if the wind shifts
and I start to fall?
What happens to all my stuff?
I don't think a bird's eye view is
what I want!

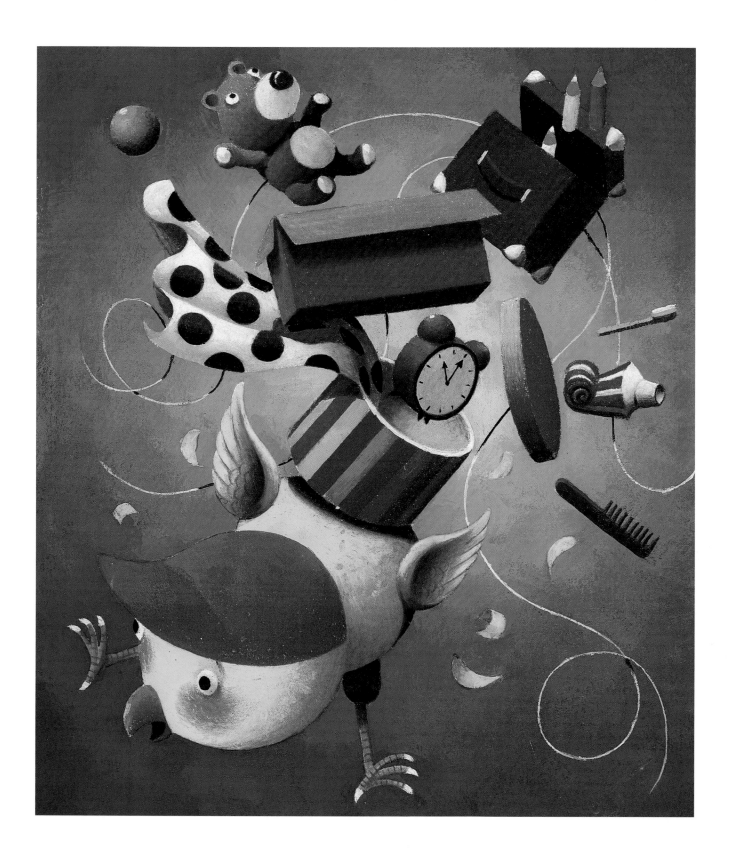

And that's when I wake up to find
I've spent my whole night dreaming.
The sun is out, it's a brand new day.
I think it's time for me to be...

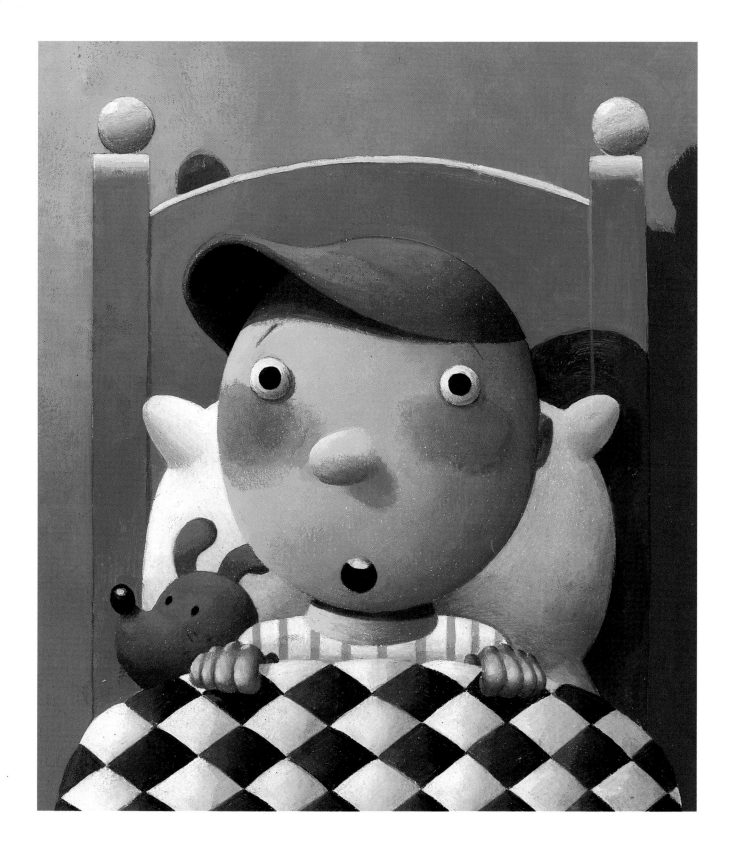

# Me!

'Cause I'm happy with me!

(At least until tonight.)

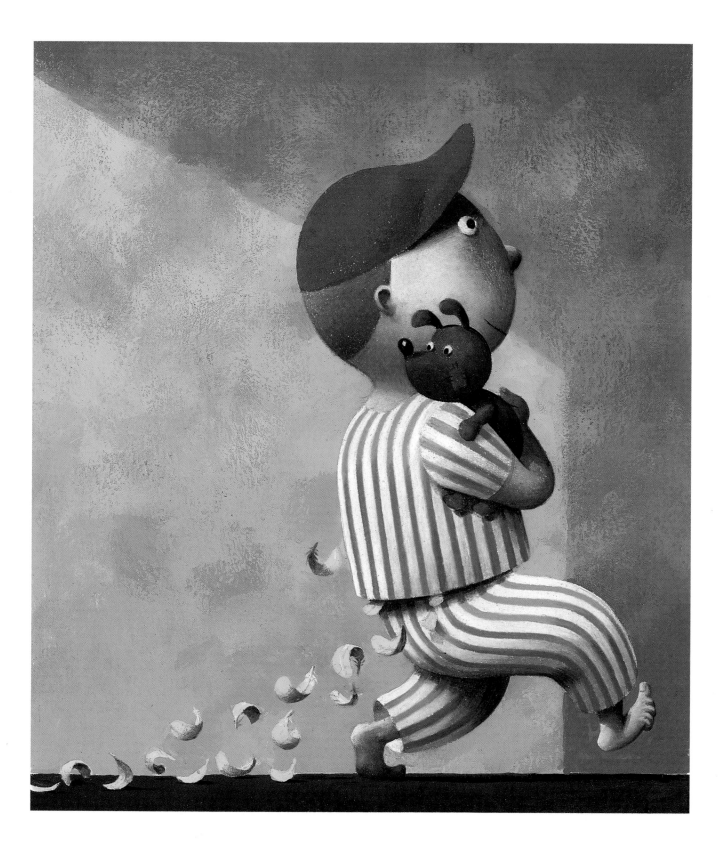

smallfell⊙w
press

Published by
smallfellow/Tallfellow Press, Inc.
and
Every Picture Press... Inc.
1180 S. Beverly Drive, Los Angeles, CA 90035

Distributed by
Andrews McMeel Distribution Services
4520 Main Street
Kansas City, Missouri 64111

English Translation Copyright © 2002 smallfellow/Tallfellow Press, Inc.

Adapted by Lee Cohen

First published in Belgium by Uitgeverij Clavis Amsterdam-Hasselt, 1999
Text and illustrations copyright © Uitgeverij Clavis Amsterdam-Hasselt, 1999.
All rights reserved. Without limiting the rights under copyright reserved above, no part of this
publication may be reproduced, stored in or introduced into a retrieval system, or transmitted,
in any form or by any means (electronic, mechanical, photocopying, recording or otherwise),
without the prior written permission of both the copyright owner and the above publisher of this book.

ISBN 1-931290-08-3

Printed in Belgium

10 9 8 7 6 5 4 3 2 1